WATFORD

HISTORY TOUR

ALSO BY JOHN COOPER

A Harpenden Childhood Remembered: Growing up in the 1940s & '50s
Making Ends Meet: A Working Life Remembered
A Postcard From Harpenden: A Nostalgic Glimpse of the Village Then and Now
Watford Through Time
A Postcard From Watford
Harpenden Through Time
Rickmansworth, Croxley Green & Chorleywood Through Time
Hertfordshire's Historic Inland Waterway: Batchworth to Berkhamsted
Harpenden: The Postcard Collection

First published 2016

Amberley Publishing
The Hill, Stroud,
Gloucestershire, GL5 4EP
www.amberley-books.com

Copyright © John Cooper, 2016
Map contains Ordnance Survey data
© Crown copyright and database right
[2016]

ISBN 978 1 4456 5777 6 (print)
ISBN 978 1 4456 5778 3 (ebook)

British Library Cataloguing in
Publication Data.
A catalogue record for this book is
available from the British Library.

Typesetting by Amberley Publishing.
Printed in Great Britain.

INTRODUCTION

During the early part of the twentieth century, countless images of Watford were captured on camera by a small but dedicated group of photographers. The numerous pictures they took provided an everlasting legacy of the town's development and recorded for posterity copious street scenes and buildings, many of which are now listed and preserved. Without their enthusiasm and commitment in recording mostly everyday views and occurrences, much of Watford's pictorial history would have been lost forever.

One of the important by-products of all these images was the picture postcard, a popular and fast means of communication in Edwardian times, where a message sent in the morning was often guaranteed to be received the same day.

Using a selection of these old postcards, many of which have been stored in dusty attics untouched for generations, this nostalgic glimpse into the Watford of yesteryear takes the reader on a fascinating tour around the town, starting from the Grove, once the delightful home of the earls of Clarendon, along the towpath of the picturesque Grand Union Canal, the Hertfordshire section completed between 1797 and 1798, and through the beautiful parkland where Cassiobury House once stood, the seat of the earls of Essex. The house had been built and rebuilt several times since its original construction was commenced by Sir Richard Morrison in the mid-sixteenth century. It was demolished in 1927.

After a brief visit to Cassio Hamlet, we wander through areas of Nascot and St Albans Road towards North Watford, stopping to view the remnant of the old railway station that was built in 1837, the same year that the London and Birmingham Railway arrived in Watford. In 1858 a new station, Watford Junction, was constructed on the site that it occupies today.

Our leisurely stroll includes visits to St Andrew's Church in Church Road, Nascot, and what used to be the London Orphan Asylum, located a short distance from the Junction, before returning to the High Street to continue our journey. As we pass the Pond where countless children once sailed a toy yacht, and horses were watered in the heat of a summer's afternoon, we reflect on what it must have been like during those early days of the twentieth century when nannies from the big houses once walked with their young charges.

We pause for a moment to admire the beautiful parish church of St Mary built in 1230, and the old Free School founded in 1704 by Elizabeth Fuller, situated at the south-west corner of the churchyard. We then reach the area where the old market, granted by charter in the reign of Henry I, was held, where the lowing of cattle once mingled with the shouts and buzz of conversation from the many traders. After visiting the fine Georgian mansion that is Watford Museum, located on part of the old Benskin's Brewery site, we arrive at the River Colne in the shadow of the Five Arches railway viaduct. It was here that a bathing area was cordoned off in the latter part of the nineteenth century to form a large square-shaped lido, a popular venue for swimmers until it eventually closed in 1936 due to its unhygienic condition.

With our History Tour now at an end, we reminisce on a journey that has given us a brief and memorable glimpse of Watford past. Despite the many changes and modernisation that has taken place as part of continuing progress, the town can be justifiably proud of its history for the benefit of future generations.

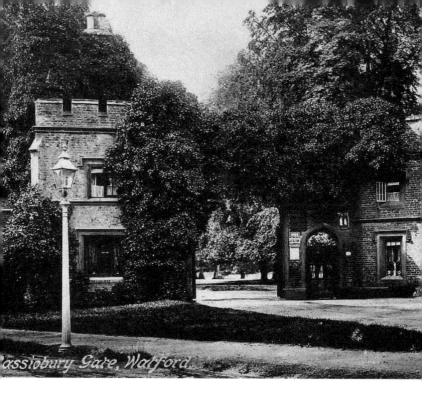

Cassiobury Gate, Watford.

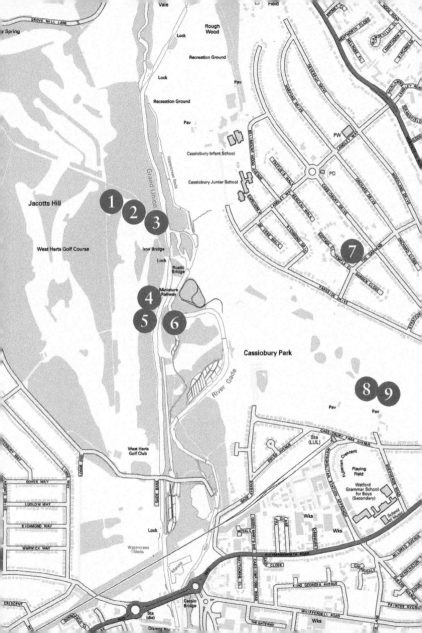

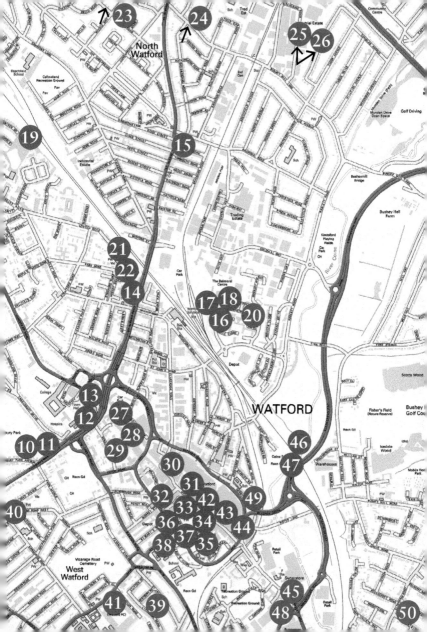

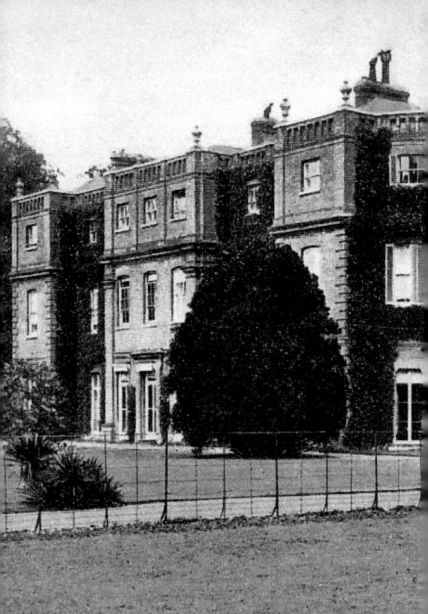

The Grove Watford, The Seat of

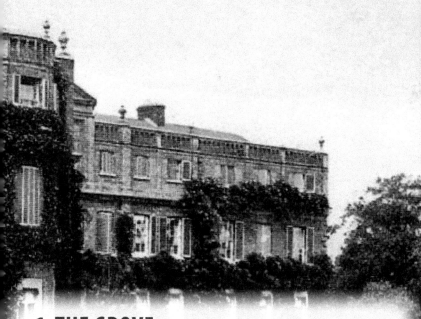

1. THE GROVE

The Grove, formerly the lovely home of the earls of Clarendon, is situated in 300 acres of fine parkland and woods, and is believed to have been built in 1756 by Sir Robert Taylor, although some sources suggest this could have been earlier. Following the Earl of Clarendon's move to his London home in the early 1920s, and the subsequent sale of the estate in 1936, the Grove has served many purposes, including a high-class girls' school, and passed through many hands, such as those of British Rail, who used the building as a training centre. Today it enjoys a new renaissance as a luxury hotel, spa and golf resort.

Earl of Clarendon.

2. GROVE MILL

The focal point of this tranquil setting was Grove Mill, built in 1875 to produce flour for the Grove Estate; the miller and his millhands lived in the adjoining house and cottages. The small wooden structure attached to the top level of the mill was known as a lucum, or sack hoist, where the newly delivered bags of corn were lifted by chain from the cart below. Once the flour had been ground, the reverse process would take place with the sacks being lowered onto the waiting transport for delivery to the estate. Following a long period of disuse when the old mill fell into a state of disrepair, it eventually underwent a complete renovation and was tastefully converted into flats during the early 1970s.

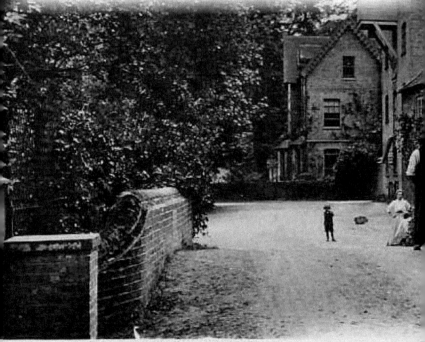

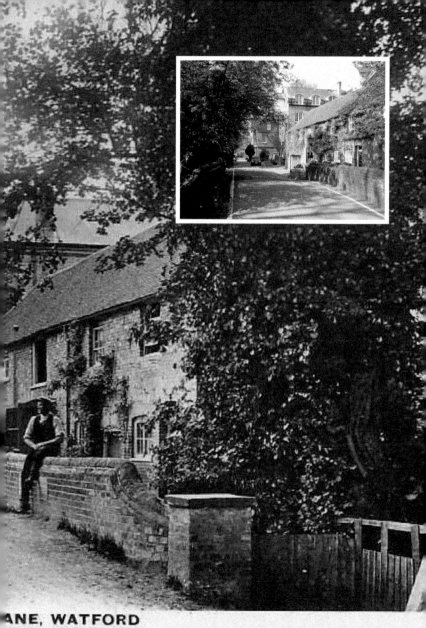

ANE, WATFORD

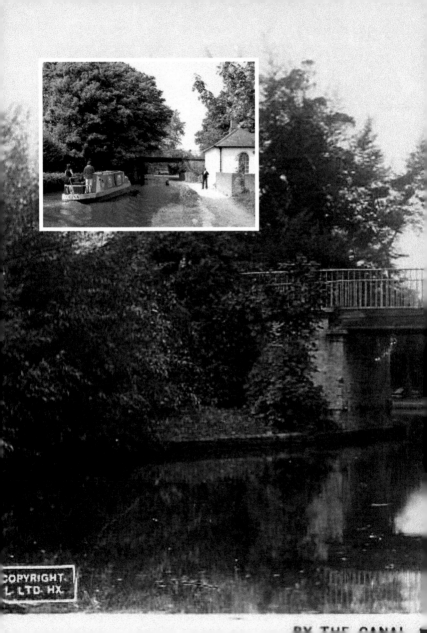

BY THE CANAL

3. GROVE MILL BRIDGE

It seems barely possible that over eighty years separates the old picture and the tranquil modern-day inset image of Grove Mill Bridge, with very few obvious changes having taken place. The small house on the right is Canal Cottage, which was built *c.* 1800 by the Grand Junction Canal Co. as accommodation for one of their employees. It was his job to collect tolls from passing narrowboats and to ensure that there was an adequate supply of water to the nearby Grove Mill. The photograph would have been taken in the late 1920s or early 1930s, with the man in shirtsleeves almost certainly the occupier of the cottage.

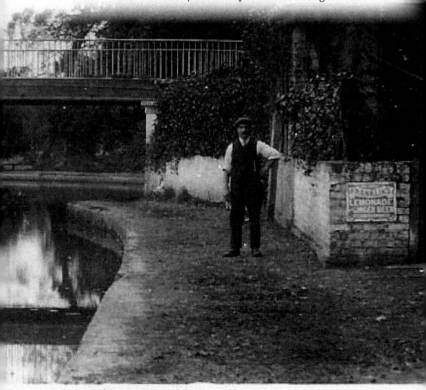

4. IRON BRIDGE LOCK

Dating from around 1921, this scenic view of Cassiobury Park's Iron Bridge Lock and the lock-keeper's cottage contrasts considerably with the modern-day image taken from the adjacent Bridge No. 167, which during the summer months attracts a great many visitors who come to watch the many narrowboats passing through the lock. The cottage was demolished during the late 1920s or early 1930s.

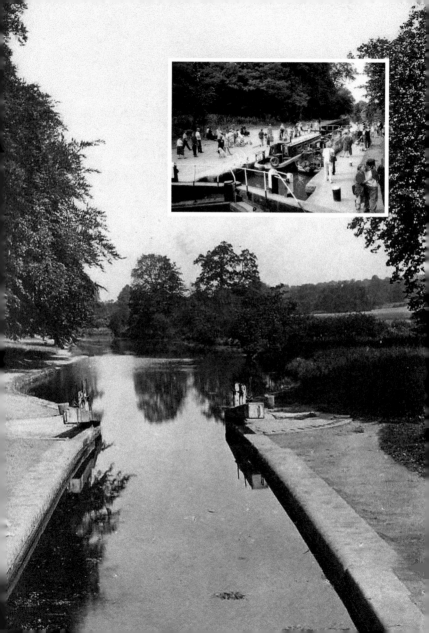

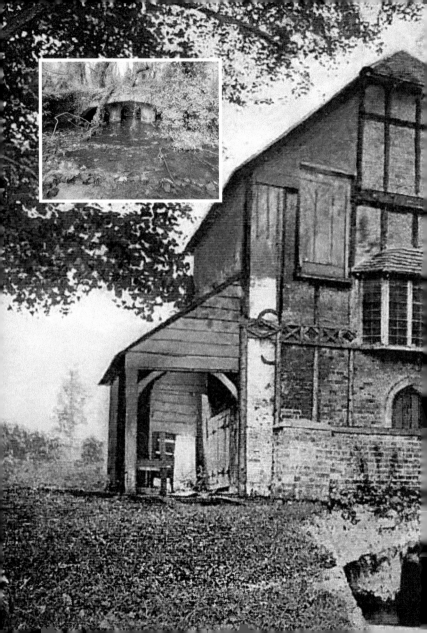

5. THE OLD MILL

Originally used for the grinding of corn and later utilised to pump water to Cassiobury House, the Old Mill, situated near the weir at the bottom of the park, adjacent to the canal, fell into disuse following the demolition of the mansion in 1927. The dilapidated structure was eventually knocked down and removed in 1956, although the arched foundations over the mill stream are still visible today.

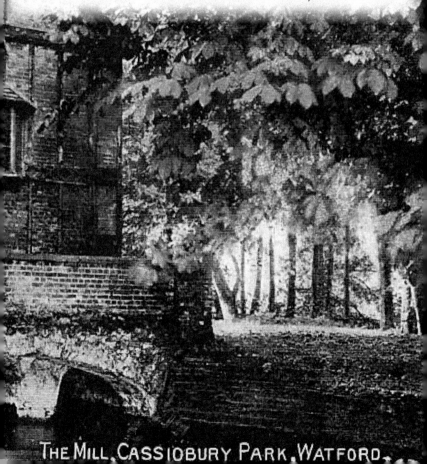

THE MILL, CASSIOBURY PARK, WATFORD.

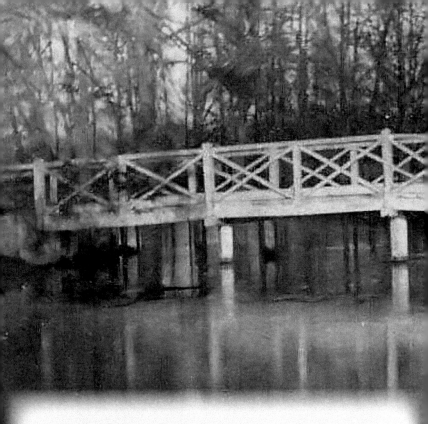

6. THE RUSTIC BRIDGE

This snapshot taken at the turn of the nineteenth century shows two children posing for the photographer at what is now known as the Rustic Bridge. Although the structure of the bridge has altered over time, this peaceful spot by the River Gade at the bottom of Cassiobury Park remains virtually unchanged. The river, which is very shallow at this point, attracts numerous youngsters during the hot, lazy days of summer when, armed with fishing net and jam jar, they attempt to catch the ever-elusive minnows in the clear water.

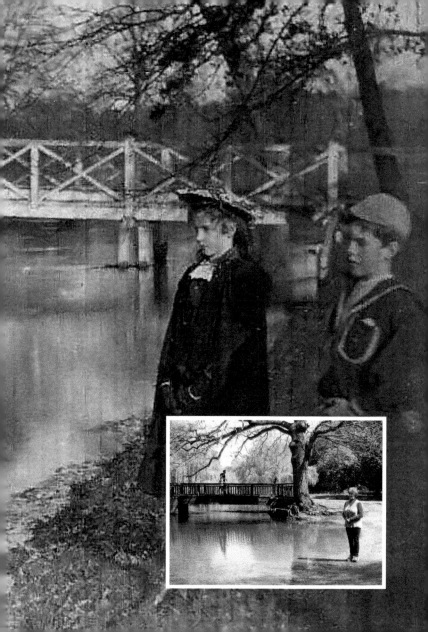

7. CASSIOBURY HOUSE

Pictured in the early 1900s, it is difficult to imagine that twenty-five years later this magnificent mansion, Cassiobury House, seat of the earls of Essex, would be no more. Situated near Temple Close and the tennis courts on what was once the Cassiobury Estate, the house had been built and rebuilt several times since its original construction was commenced by Sir Richard Morrison in the mid-sixteenth century. Following the death of the 7th Earl, George Devereux de Vere Capell, in 1916, his wife Adele, the Countess Dowager of Essex, sold the estate in 1922, but with no purchaser for the house it was left empty and derelict for a further five years until its demolition in 1927.

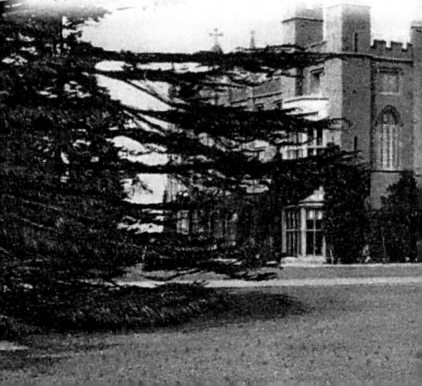

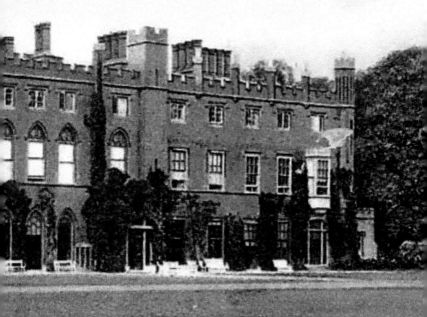

Cassiobury, Watford.

8. THE PAVILION TEAROOM

Constructed during the 1930s, this rather autumnal-looking postcard depicts the Pavilion Tearoom with the Cassiobury Park fountain in the foreground. Although the fountain was removed sometime after the mid-1960s, the tearoom remains and today is the popular Cha Café which throughout the year provides an invaluable service to all who visit our lovely park.

9. THE BANDSTAND

Each Sunday throughout the summer months, the rousing marches of John Philip Sousa and other well-known composers could be heard echoing around Cassiobury Park as a military band played to a captive audience from the fine Edwardian bandstand situated near the path leading to Stratford Way, a short distance from the Pavilion Tearoom. For 3*d*, the price of a deckchair, one could sit and relax, listening to the music and watching the world go by.

10. PARK GATES

The historic, castellated, Tudor-style Lodge Gates giving access from Rickmansworth Road to the lovely Cassiobury Park were originally built as the entrance to the long driveway leading to Cassiobury House, but due to an 'essential' road-widening scheme, their fate was sealed and they had to go, with demolition taking place on 24 July 1970 – a sad day indeed for Watfordians.

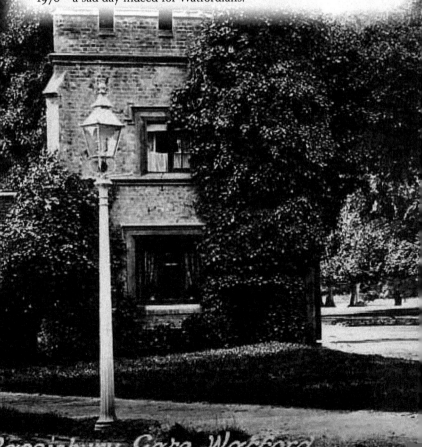

Cassiobury Gate, Watford.

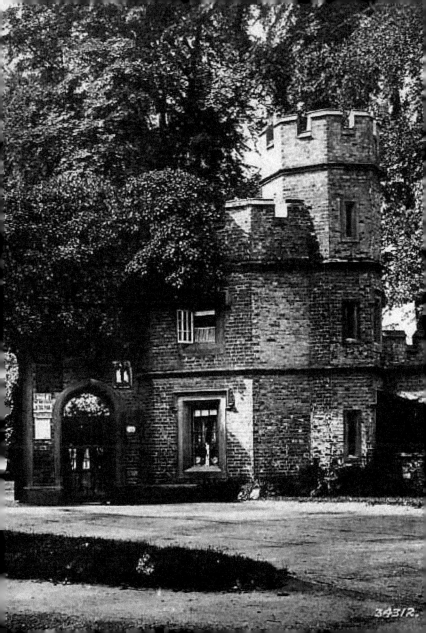

11. PEACE MEMORIAL HOSPITAL

Opened in 1925 by the Princess Royal at a cost of £90,000, the Peace Memorial Hospital was built to replace the old Cottage Hospital in Vicarage Road, although by the late 1930s even this new accommodation was found to be inadequate to meet the needs of a fast expanding area. With the expansion of the West Herts Hospital in Vicarage Road, the Rickmansworth Road site eventually closed, and although much of the old hospital infrastructure has now disappeared, the original building remains as the Watford Peace Hospice.

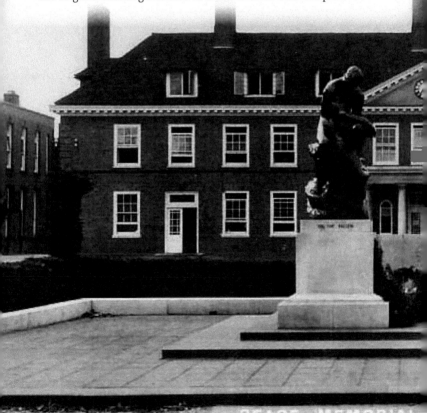

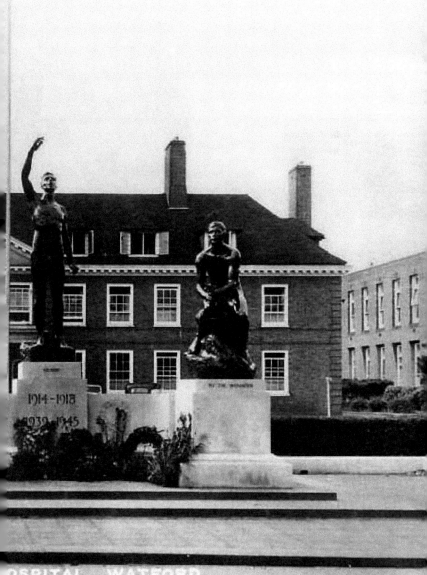

1914-1918
1939-1945

BY THE WOMEN

OSPITAL, WATFORD,

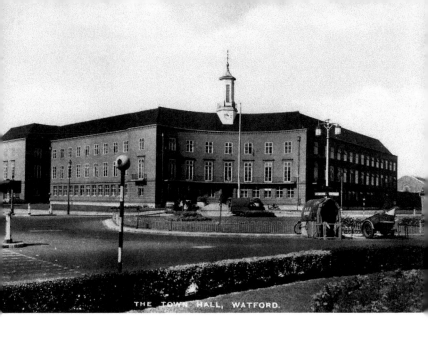

THE TOWN HALL, WATFORD.

12. TOWN HALL

Built at a cost of £186,000, the splendid new Town Hall and municipal offices were constructed on the site of 'The Elms', originally known as 'Town End House', an early eighteenth-century mansion that had occupied a position on one corner of what used to be the Cross Roads at the northern end of the town. This magnificent building, designed by the architect Charles Cowles-Voysey, was opened on 5 January 1940 by Lady Clarendon, and replaced the previous centre of local government at Upton House in the High Street.

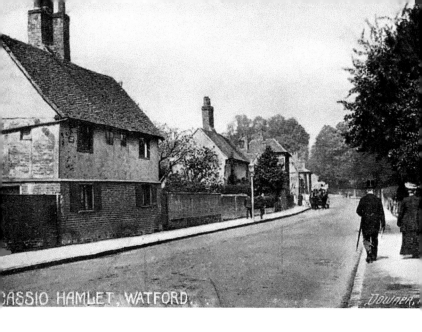

CASSIO HAMLET, WATFORD. DOWNER.

13. CASSIO HAMLET

This quiet Edwardian image taken in the early 1900s shows the area known as Cassio Hamlet just north of where the Town Hall is now situated. It consisted of a small cluster of cottages and two public houses, the Dog and the Horns, both well frequented by carters passing through the hamlet with their horse-drawn haywains on their way to the weekly livestock market in the centre of Watford. Although the cottages and the Dog have long gone, the Horns still remains, enjoying considerable recognition as a live music venue.

14. ST ALBANS ROAD (1)

Captured in the early years of the twentieth century, this snapshot shows a fairly busy St Albans Road taken from the bridge looking towards the junction with Station Road and Langley Road. While the buildings on the left have long been demolished to make way for road widening, some of the architecture on the right has survived with little change to the first floor level and above over the intervening years.

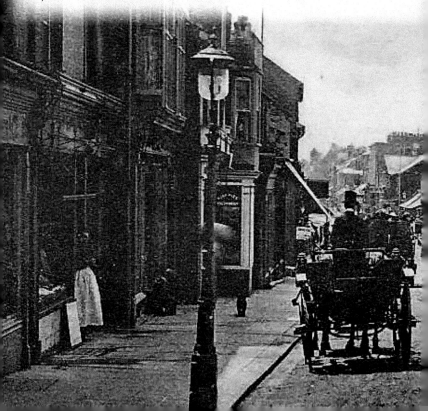

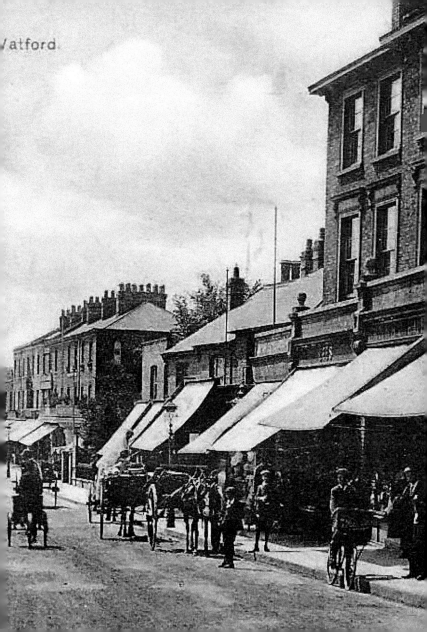

15. ST ALBANS ROAD (2)

This superb postcard from the summer of 1915 shows St Albans Road, frozen in time, at the junction with Cromer Road, although today there is now no longer any access onto the main thoroughfare. On the right-hand side, the shop on the corner that undertakes piano repairs has what appears to be a selection of sheet music on display, while the window to the side of the entrance door is advertising the sale of 'Picture Postcards' with a wide selection of 'Watford Views' available.

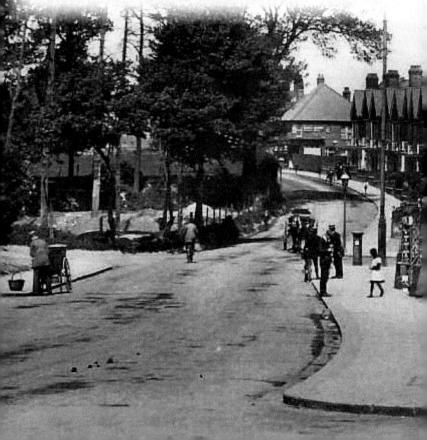

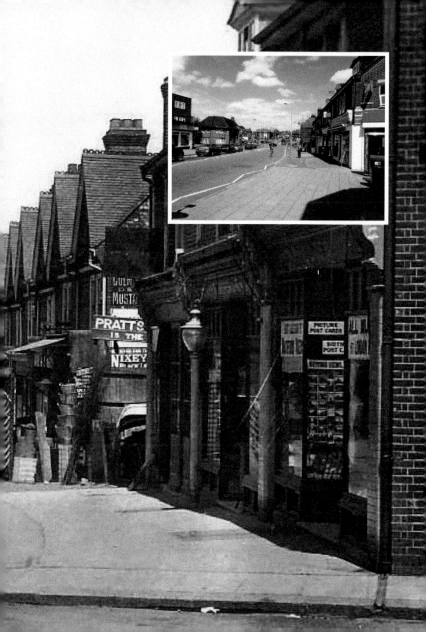

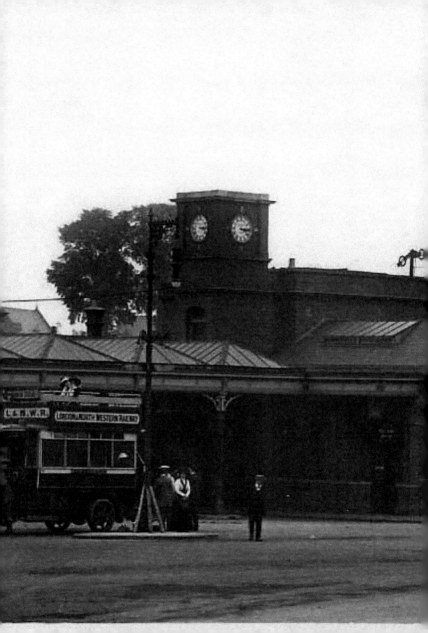

16. WATFORD JUNCTION

In 1858 a new station was constructed on the site that it occupies today. It replaced the old Grade II listed station at No. 147a St Albans Road that had been built in 1837 with the arrival through Watford of the London and Birmingham Railway. Further work was carried out on the station in 1909 when the front was extended and rebuilt. A new Watford Junction with office facilities replaced the old one in 1985.

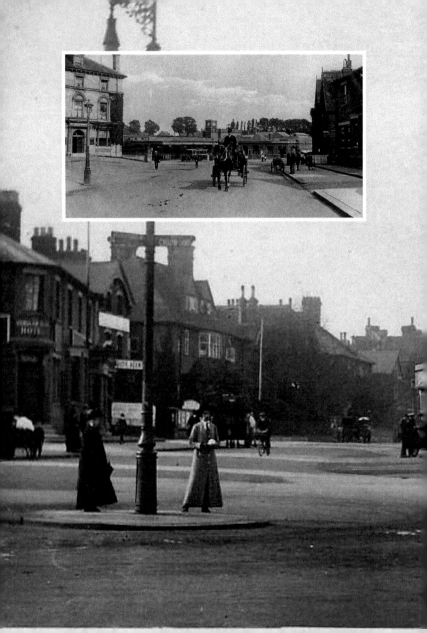

17. STATION ROAD

These charming postcards taken just before the outbreak of the First World War capture a moment in time as we are shown two views of Station Road, with the Clarendon Hotel and Watford Junction in the background of the inset picture.

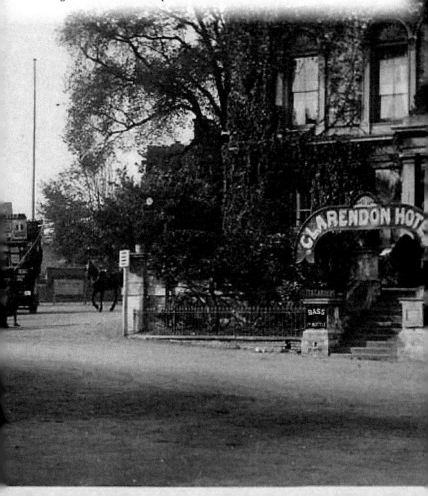

18. THE CLARENDON HOTEL

Built in 1860, the Clarendon Hotel is seen above in the Edwardian era when the proprietor was Captain H. Brydges. Over the years there have been several name changes including the Pennant, the Flag and Firkin, and it is now enjoying immense popularity as the Flag, 'the most established music venue in Watford'. On 12 September 1975 the building was given Grade II listed status.

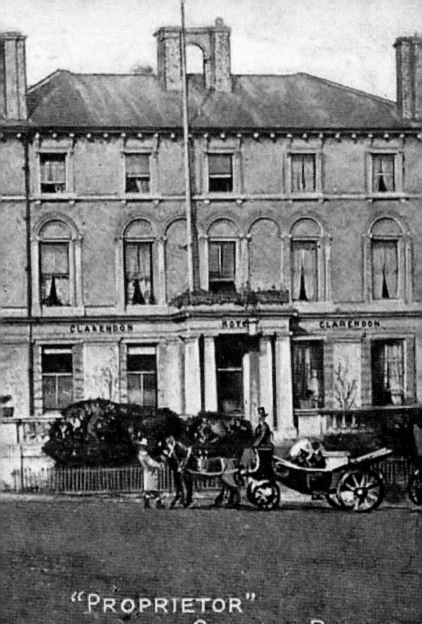

"PROPRIETOR"
CAPTAIN BRYDGE

19. WATFORD TUNNEL

Watford Tunnel under construction, 6 June 1837. Originally, the route of the railway was planned to pass through the estates of the earls of Essex and Clarendon, but due to their opposition, a new route that necessitated a cutting north of Watford Junction was put in place. The tunnel was 1 mile 170 yards long, 25 feet high and 24 feet wide and accommodated a two-track line. Ten workmen lost their lives during the excavation.

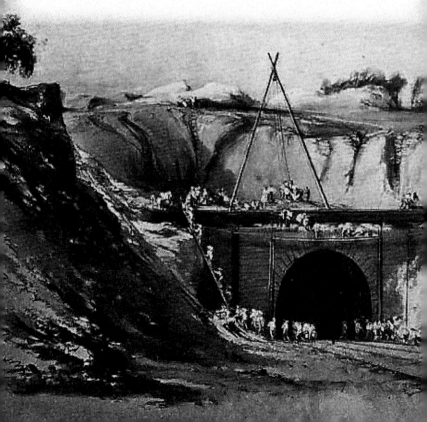

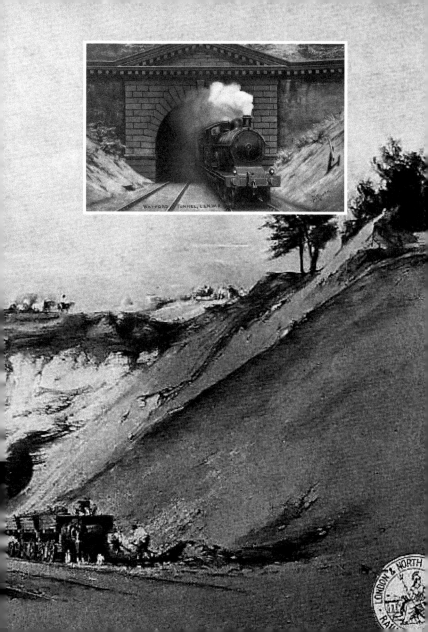

WATFORD TUNNEL, L&N.W.R.

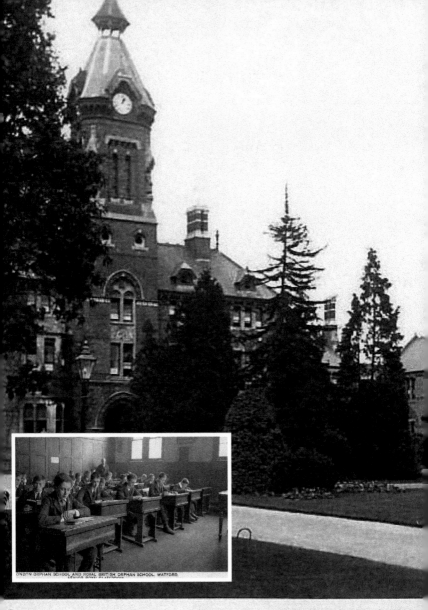

LONDON ORPHAN SCHOOL AND ROYAL BRITISH ORPHAN SCHOOL, WATFORD. SENIOR BOYS' CLASSROOM.

20. LONDON ORPHAN ASYLUM

Originally based in Clapton, the London Orphan Asylum was founded in 1813 by Andrew Reed for 'the education of respectable fatherless children of either sex'. Following a serious outbreak of typhus in London, the asylum moved to a beautiful site in Watford in 1871 where there was accommodation for 600 orphans. In 1915 it was renamed the London Orphan School and again as Reed's School in 1939. The inset image is a carefully posed picture of the senior boys' classroom. During the 1980s, following the granting of Grade II listed status in 1983, the buildings were converted into residential accommodation.

ASYLUM, WATFORD

21. ST ANDREW'S CHURCH, CHURCH ROAD

With the opening of the London and Birmingham Railway in 1837 and a need by the company for their employees in Watford to live in close proximity to the station, land was purchased from the Earl of Essex for development. This brought about a steady influx of people into the rapidly growing area of Nascot, and it was decided that this new population needed a church to serve them, the only other Anglican place of worship at the time being St Mary's. The foundation stone of the new church of St Andrew, designed by the noted architect S. S. Teulon, was laid in 1853, with the consecration taking place in 1857.

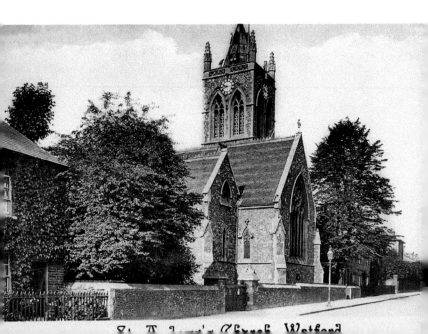

St Andrew's Church, Watford

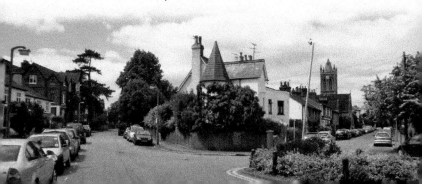

22. PARK AND CHURCH ROADS

The very distinctive-looking property in the centre of both images, at one time known as Cambridge Villa, was constructed in 1847/48 by a miller from Chipperfield called William Stapleton who, after purchasing the land from the Earl of Essex, proceeded to develop the site with two cottages. These were later amalgamated into a single dwelling house by a later owner, one Henry Henson, Gentleman, during the mid-1850s. At various times, the property is known to have been used as a bakery and a school.

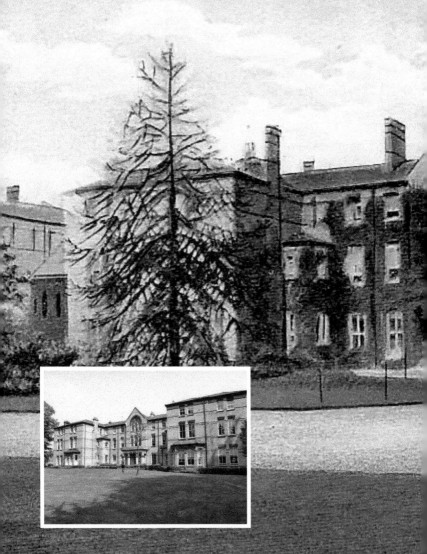

Leavesden Asylum

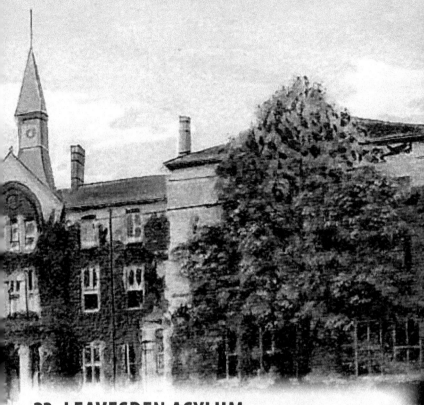

23. LEAVESDEN ASYLUM

Following the establishment of the Metropolitan Asylums Board in 1867, a new building was opened on 9 October 1870 at Leavesden for the care of the mentally handicapped. With the passage of time, the emphasis started changing from detention and segregation to prevention and treatment, leading to the gradual resettlement and integration of patients into the community. This resulted in the termination of institutions such as Leavesden, which eventually closed in October 1995. The building was then converted into private residential accommodation.

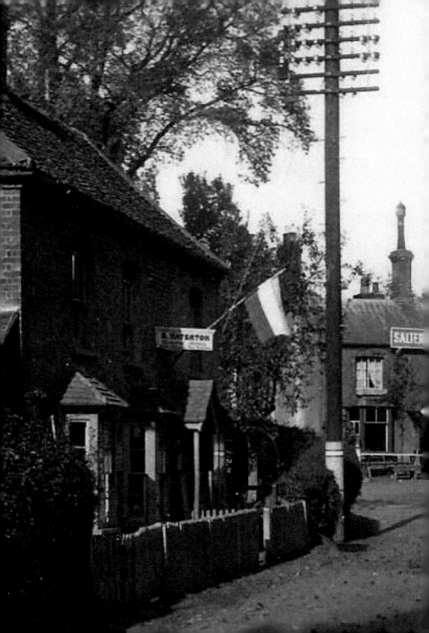

24. THE THREE HORSESHOES PUBLIC HOUSE

When compared to the earlier print photographed around 1914/15, today's view of this busy crossroads has changed out of all recognition. The group of soldiers are standing outside the Three Horseshoes public house in Garston, previously an old smithy and rebuilt around 1750, with the house on the left-hand side belonging to shopkeeper Sidney Waterton. The pub, which is the building in the centre of the inset picture, is now a flourishing Harvester Restaurant.

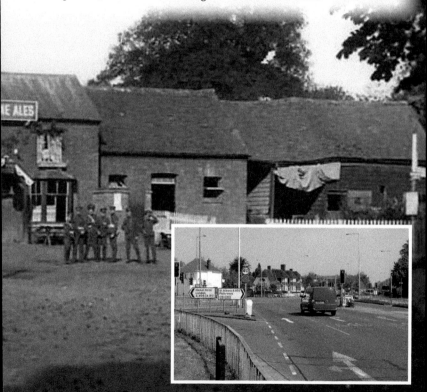

25. MOHNE DAM (1)

Bucknalls, a lovely mid-nineteenth-century mansion built in 1855 in the rolling countryside just to the north of Watford, was acquired by the then fledgling Building Research Station (BRS) in 1925, now the Building Research Establishment (BRE), one of the foremost organisations in building research, consultancy and testing in the world. It was here in a remote wooded part of the site during the dark days of the Second World War that clandestine preparations for Operation Chastise, more commonly known as the Dambusters Raid, were carried out when on the night of 16–17 May 1943, nineteen modified Lancaster bombers of No. 617 Squadron RAF Bomber Command attacked the German dams in the heart of the industrial Ruhr using the famous bouncing bombs designed by Barnes Wallis.

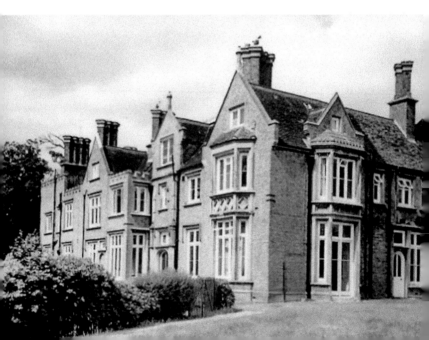

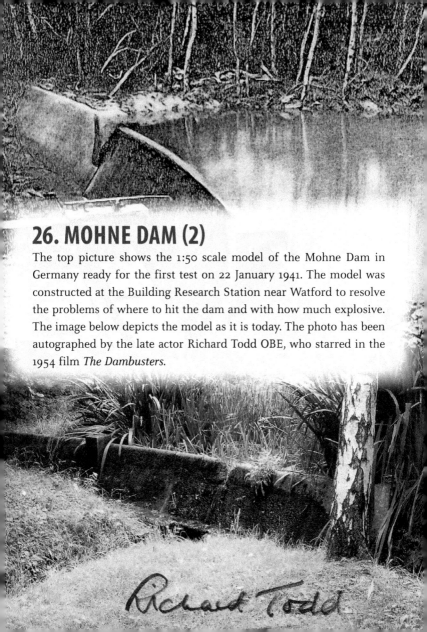

26. MOHNE DAM (2)

The top picture shows the 1:50 scale model of the Mohne Dam in Germany ready for the first test on 22 January 1941. The model was constructed at the Building Research Station near Watford to resolve the problems of where to hit the dam and with how much explosive. The image below depicts the model as it is today. The photo has been autographed by the late actor Richard Todd OBE, who starred in the 1954 film *The Dambusters*.

27. THE POND

Photographed countless times and the subject of numerous picture postcards, the Pond just south of the Town Hall has provided a constant source of pleasure and delight to thousands of people for well over 100 years. This picturesque oasis in Watford's town centre has seen many changes, from excited youngsters floating their toy yachts in the early 1900s and horses being watered in the heat of a summer's afternoon, to the peaceful scene depicted today.

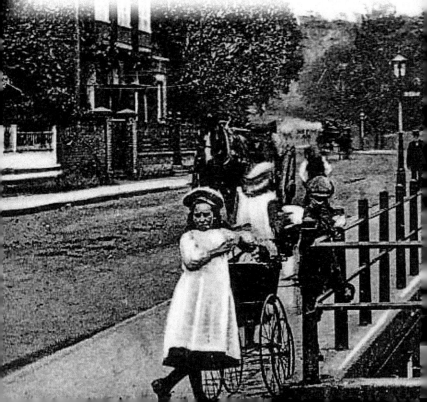

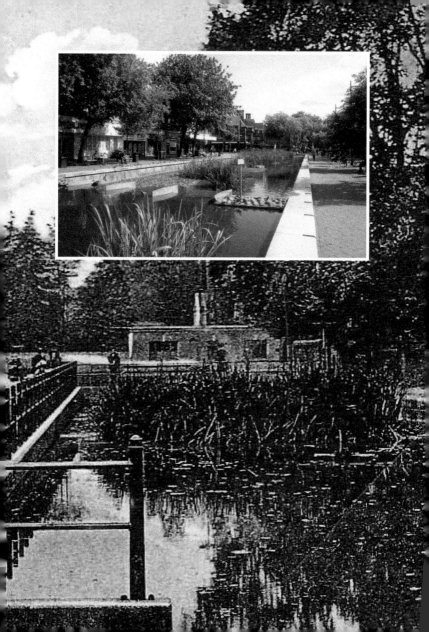

28. MONMOUTH HOUSE

Situated at the northern end of the High Street and originally called the Mansion House, this early seventeenth-century Grade II listed building was constructed by Sir Robert Carey, the 1st Earl of Monmouth, who took the news of Queen Elizabeth's death to her successor, James I, in 1603. Following Robert's own death, the house was occupied as a Dower House by his widow Elizabeth until her demise in 1641. In 1771 the accommodation was divided into two and altered in 1830, the north part being called Monmouth House and the south the Platts. During the late 1920s the building was converted to business premises and retail outlets retaining the name of Monmouth House.

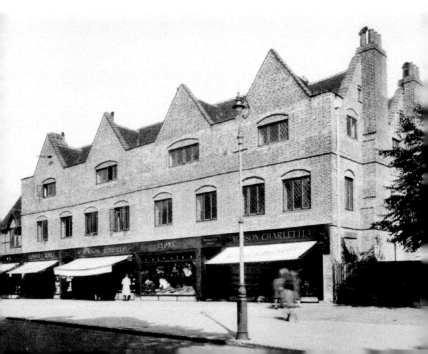

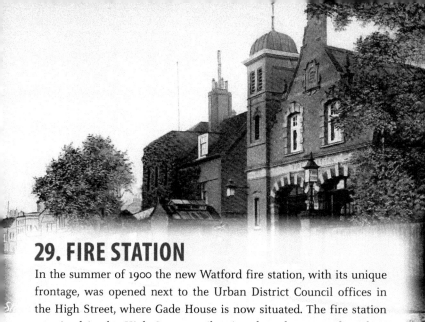

29. FIRE STATION

In the summer of 1900 the new Watford fire station, with its unique frontage, was opened next to the Urban District Council offices in the High Street, where Gade House is now situated. The fire station remained in the High Street until 1961, when they moved to their newly built £80,000 premises at the junction of Rickmansworth Road and Whippendell Road, operating from there for a further forty-eight years until a new £5 million state-of-the-art station opened in Lower High Street on 19 November 2009.

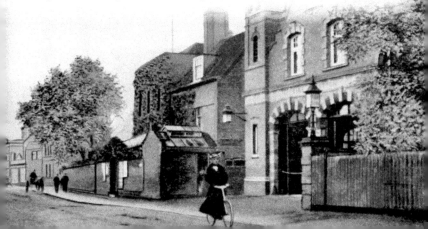

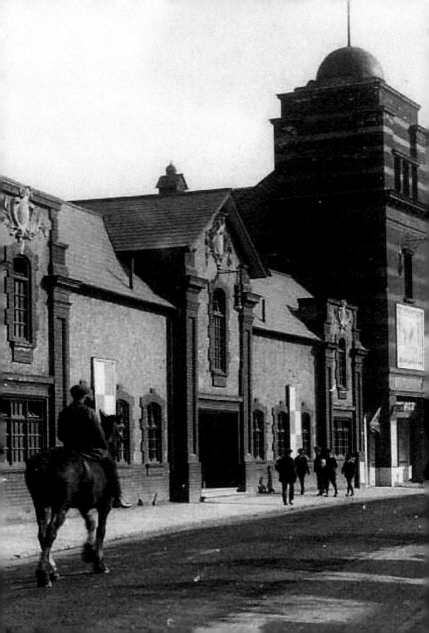

30. PALACE THEATRE

This picture postcard features the lovely Grade II listed Palace Theatre, which opened its doors to the public on Monday, 14 December 1908 'with a High Class Vaudeville Company' under the direction of T. M. Sylvester. Whereas other provincial theatres have sadly closed, the Palace has thrived for over 100 years, providing first-rate and varied entertainment to the local community and beyond.

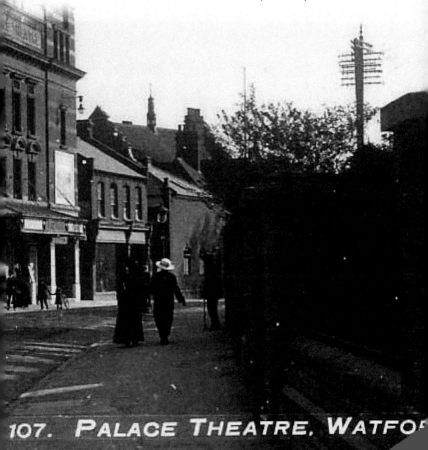

107. PALACE THEATRE, WATFO

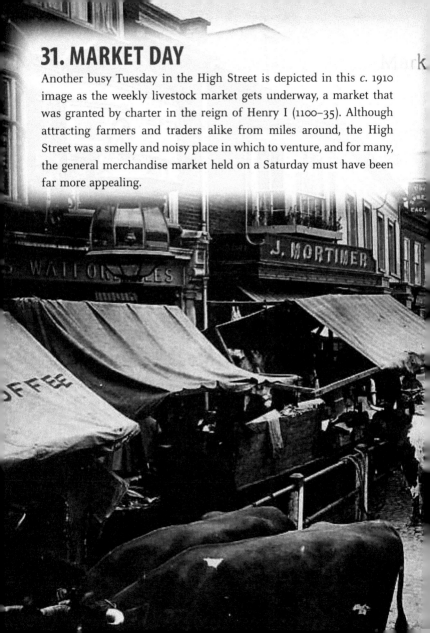

31. MARKET DAY

Another busy Tuesday in the High Street is depicted in this *c.* 1910 image as the weekly livestock market gets underway, a market that was granted by charter in the reign of Henry I (1100–35). Although attracting farmers and traders alike from miles around, the High Street was a smelly and noisy place in which to venture, and for many, the general merchandise market held on a Saturday must have been far more appealing.

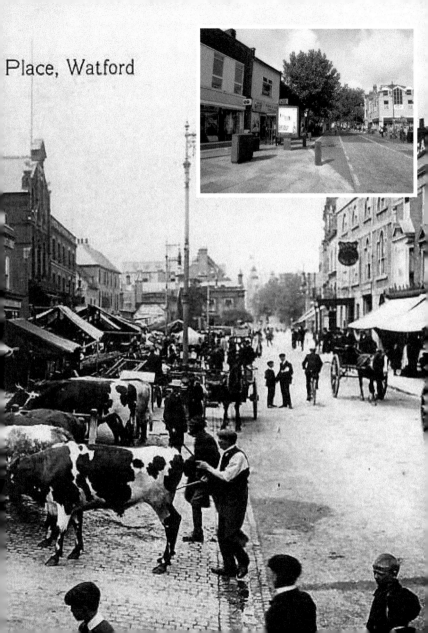

Place, Watford

32. THE COMPASSES PUBLIC HOUSE

The Compasses public house, situated on the corner of the High Street and Market Street, was built around 1725, and is pictured here in 1890. In 1888/89, following a partial demolition of the premises next door when Market Street was opened up, a fifteenth-century window was discovered which is still preserved to this day. Moss, the menswear retailer, now occupies the premises.

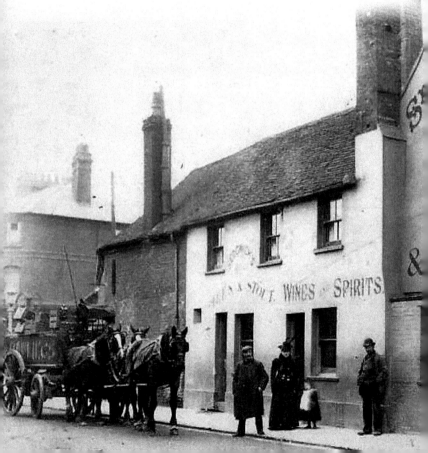

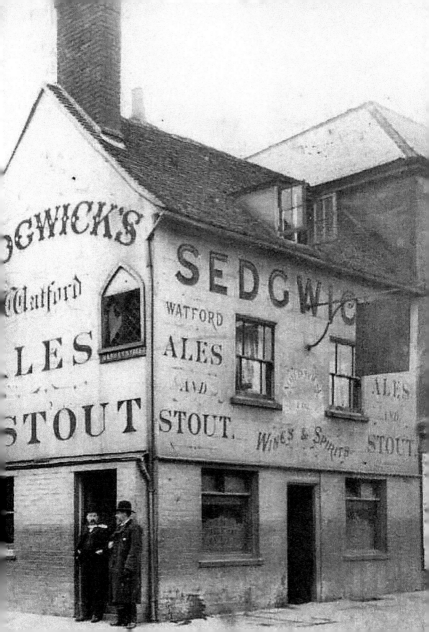

33. ST MARY'S PARISH CHURCH

This lovely snow scene of the beautiful Church of St Mary was photographed on Friday 24 April 1908 and is depicted here by the Watford Engraving Co. The church was built around 1230, although the imposing bell tower was added during the fifteenth century. The road in front of St Mary's, appropriately named Church Street, was once home to the workhouse and the engine house for the parish manual fire pump.

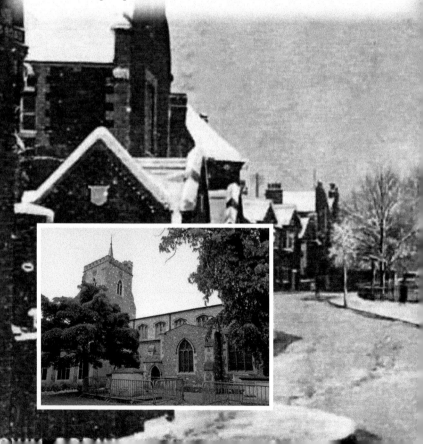

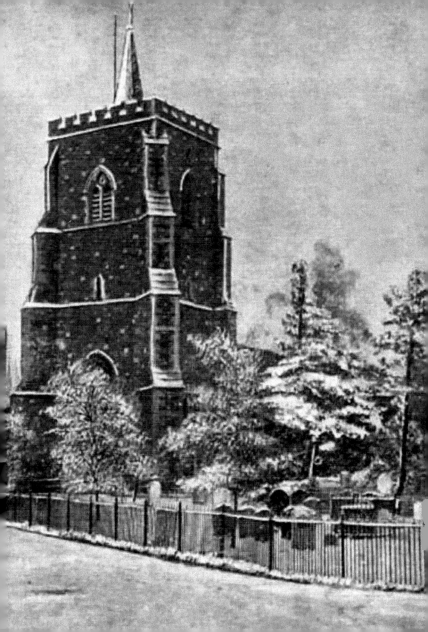

34. THE FIG TREE TOMB

One of Watford's strangest legends is that of the Fig Tree Tomb in St Mary's churchyard. So the myth goes, a lady who was an atheist was buried in a vault close to the wall of the church. On her deathbed she is reported to have expressed a wish that if there was a God, a fig tree might grow from her heart. Whatever the story, a fig tree did indeed grow from the tomb, and remained there until it died in the severe winter of 1962/63. The fig tree can just be seen on the right-hand side of this early 1900s picture.

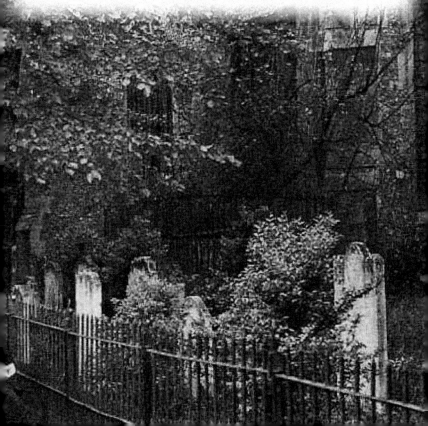

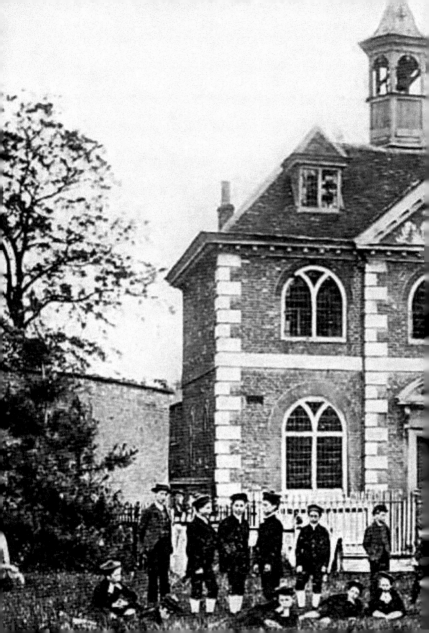

35. THE FREE SCHOOL

Built in 1704, the Free School was founded by Elizabeth Fuller as a charity 'for the teaching of forty poor boys and fourteen poor girls of Watford in good literature and manners'. With the aid of endowments and bequests, this elegant Grade II listed Queen Anne institution survived for almost 180 years when charity schools as such ceased to function. Following its closure in 1882, the establishment was transferred to a new building in Derby Road called the Endowed School, the precursor of the Watford Grammar Schools for Boys and Girls. The inset picture shows the new Grammar School for Girls, which opened in September 1907.

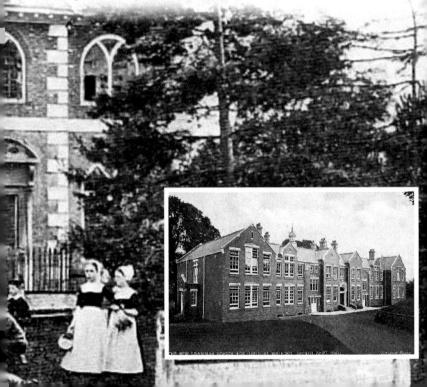

THE NEW GRAMMAR SCHOOL FOR GIRLS, AT WATFORD. OPENED SEPT. 1907.

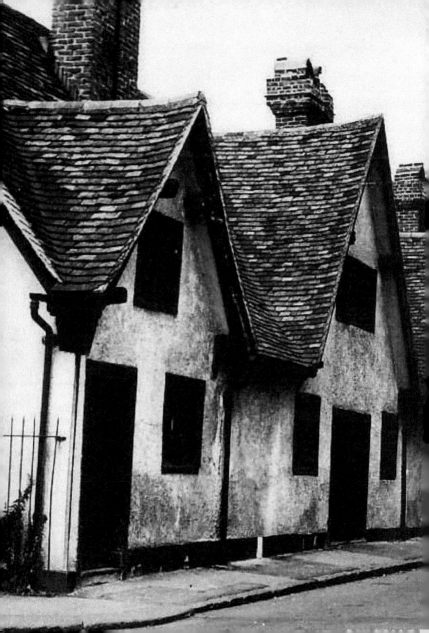

36. ESSEX ALMSHOUSES

These beautifully preserved Grade II listed almshouses in Church Street were built in 1580 by Francis Russell, 2nd Duke of Bedford, so that 'eight poor women might inhabit and be maintained in the said eight almshouses'. Due to their dilapidated condition in the early 1930s, a successful appeal was made to preserve the buildings, which today remain the oldest inhabited dwellings in Watford.

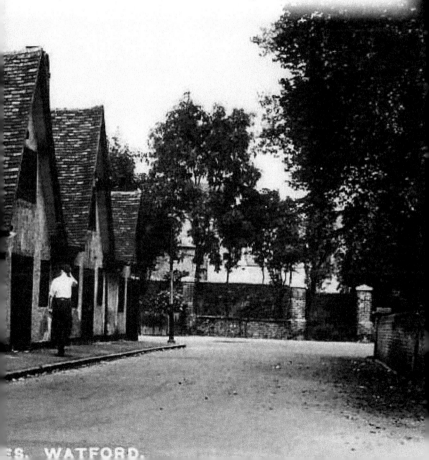

ES. WATFORD.

37. MATERNITY HOME

Straddling what is now the ring road, Watford Maternity Home was opened at No. 21 King Street in 1935 and rebuilt in 1937 by the county council, who had taken over the management of the building from the County Nursing Home Association. Following a brief period as the maternity wing of the newly formed Watford General Hospital, it eventually closed in 1969 when a new maternity unit opened at the hospital in Vicarage Road. The home was demolished as part of a road-widening scheme, with new housing in King's Close now occupying part of the old site.

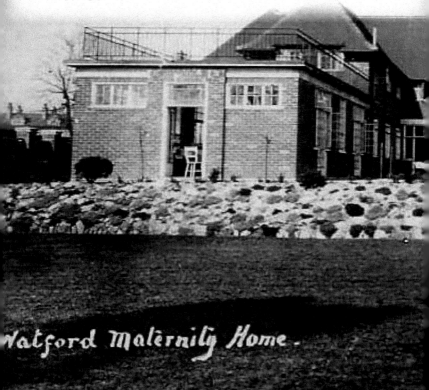

Watford Maternity Home.

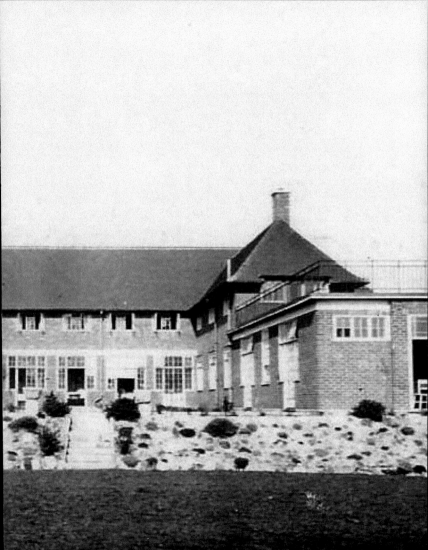

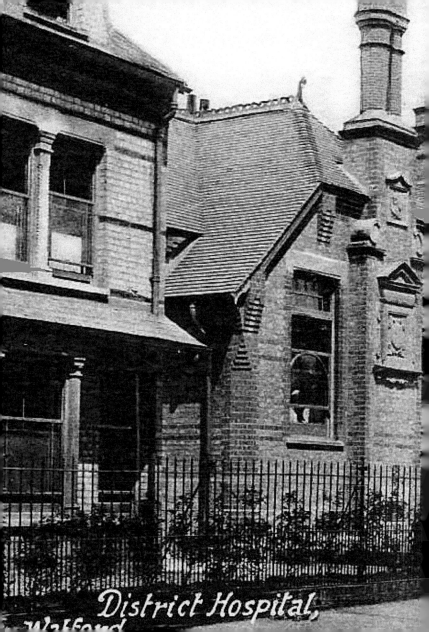

District Hospital,
Watford

38. DISTRICT HOSPITAL

Built in 1885, the Cottage Hospital (later called the District Hospital) in Vicarage Road originally had nine beds at the time of its opening, but in 1897, to mark the Diamond Jubilee of Queen Victoria, a new six-bed ward and an operating theatre were added. In 1903, new dining rooms and staff accommodation, together with two additional six-bed wards, were built to provide a total capacity of twenty-seven much-needed beds. Today, this old building is used for office accommodation.

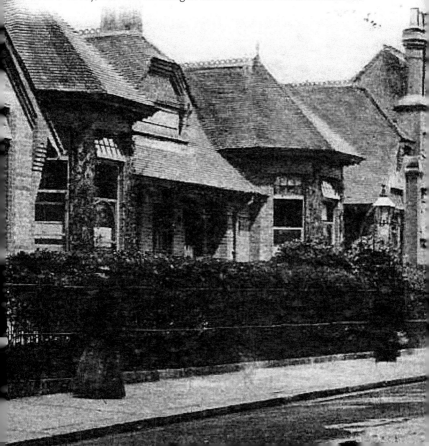

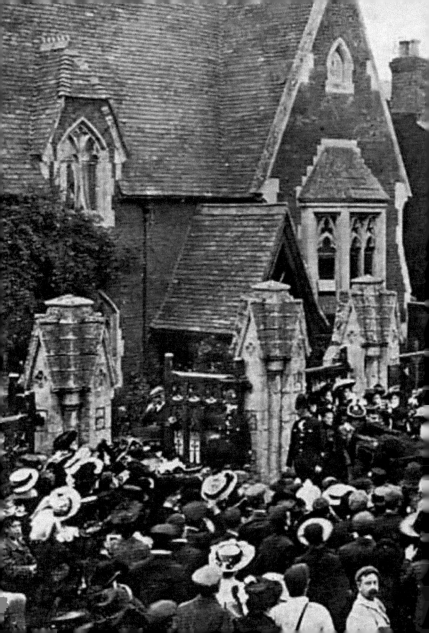

39. VICARAGE ROAD CEMETERY

One of the most bizarre pictures to be taken and used as a postcard was the funeral of a twenty-one-year-old Watford-born girl Mary Sophia Money, at the Vicarage Road Cemetery on 3 October 1905. Mary's mutilated body had been discovered in Merstham railway tunnel on the London–South Coast line during the late evening of Sunday 24 September. The two most likely trains on which she could have travelled had both emerged from the tunnel with all their carriage doors closed. Was it suicide, an accident or, as appears most likely, murder, as somebody must have closed the carriage door after Mary had fallen to her violent death? An interesting hypothesis.

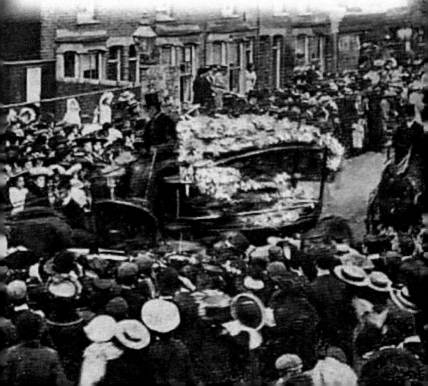

ST. MICHAEL'S CHURCH, WATFORD.

40. ST MICHAEL'S CHURCH

The distinctive-looking Church of St Michael occupies a prime position on the corner of Mildred Avenue and Durban Road West. With the rapidly expanding population in Watford, brought about by the railways and other major industries, plans were drawn up at the beginning of the twentieth century for a new church to be built to serve the spiritual needs of the growing community in the west of the town. The church, dedicated in 1905, was subsequently used as St Michael's Hall following the consecration of a new, larger building on 19 January 1913.

215293.J.V.

41. SHRODELLS

Constructed in 1838 as the Union Workhouse, this rather grim-looking early Victorian building in Vicarage Road, with its prison-like appearance, used to serve the basic needs of the poor within the parish, where they could obtain one good meal a day and a bed for the night. In 1930, the name 'Shrodells' (meaning 'shrubberies') was adopted when the Board of Guardians was replaced by the Watford Guardians Committee. The old Grade II listed institution now forms part of Watford General Hospital.

42. QUEEN'S ROAD

Posted in 1915, this charming postcard shows Queen's Road, one of Watford's busy shopping thoroughfares, at 12.15 p.m. on a warm summer's day. The Wesleyan Church in the background, which was consecrated on Wednesday 16 January 1889, was built on the corner of Derby Road at a cost of £8,800 and could seat 1,100 worshippers. Established businesses in Queen's Road at that time included the premises of William Coles, the well-known local photographer, and Elliott's, the pianoforte and music warehouse, where a piano could be purchased from 14 guineas.

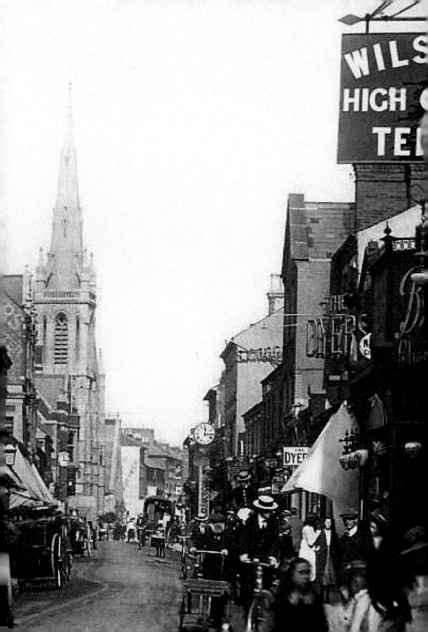

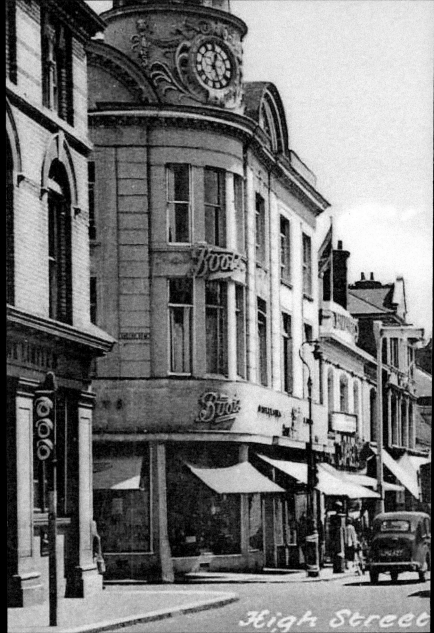

High Street

43. HIGH STREET (1)

A bright sunny day is depicted showing the junction of Queen's Road with the High Street in the early 1950s. King Street is just down on the right-hand side past Woolworth's, where Mrs L. Packer was 'Mine Host' of the King's Arms public house on the corner of what was once the gate lodge of the carriageway leading to Watford Place. A McDonald's fast food outlet now occupies the site of the old inn. On the opposite side of the High Street, where Boots the Chemists once traded, is now the imposing entrance to the Intu Watford Shopping Centre, previously the Harlequin, which opened its doors in 1992.

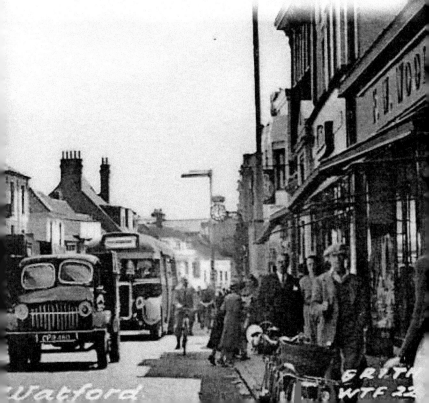

44. HIGH STREET (2)

This early snapshot of part of the High Street has captured some interesting details of the times. The advertisements on the side of the building to the left indicate that the premises there were used as a registry office for servants, probably an early type of recruitment agency, and a Circulating Library. The library, which served the general reading interests of ordinary people could, for a small fee, allow readers to access a wide range of popular reading material, although this facility started to decline in the early twentieth century with public libraries offering their services for free. To the right at No. 105 can be seen the shop of E. Sumpster, clothier, with a pony and trap parked outside – a far cry from the busy High Street that it is now.

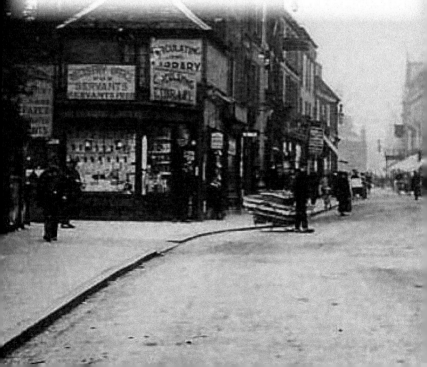

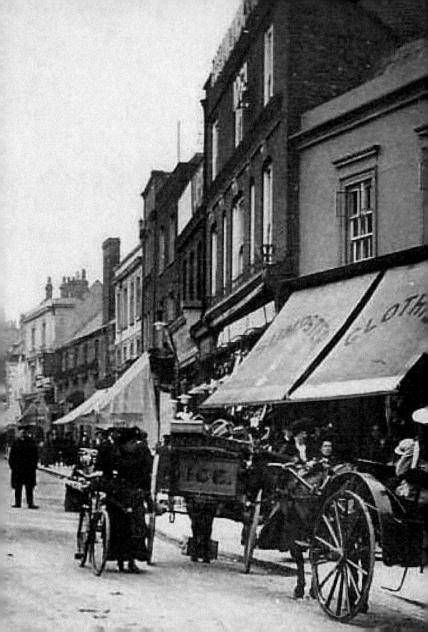

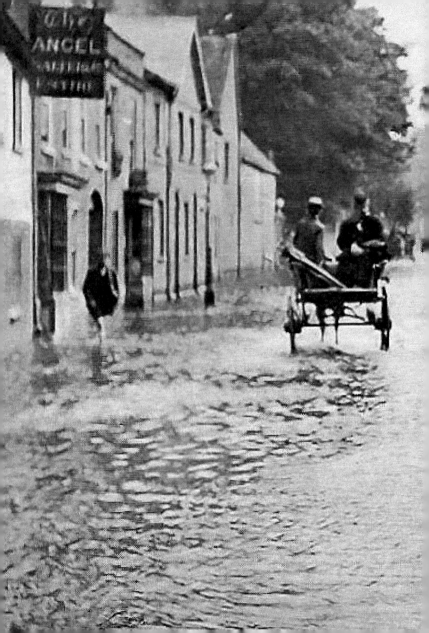

45. THE FLOOD OF 1903

Local photographer William Coles of Queen's Road snapped this watery thoroughfare at the bottom of Lower High Street near the Angel public house following the flood of Tuesday 16 June 1903. This being market day, the two drovers can be seen leading a bull to the livestock sales in the centre of town. The Angel, which was built around 1750, had only a short time left before it was demolished later in 1903, the approximate site now occupied by George Ausden, scrap iron and metal merchant.

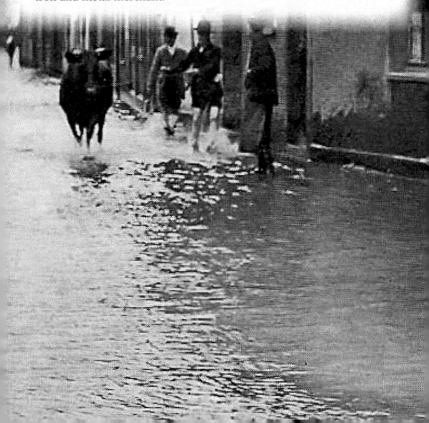

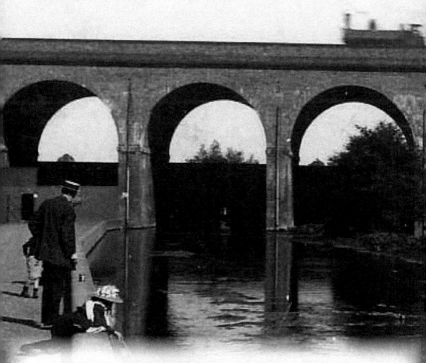

46. FIVE ARCHES RAILWAY VIADUCT

The Five Arches railway viaduct was constructed over the River Colne in the mid-1830s to accommodate the London and Birmingham Railway which opened in 1837. The obelisk that can be seen in front of the fifth arch was originally erected by the Corporation of London to mark the boundary where the payment of a 1*s.* 1*d.* duty per ton was levied on all coal being brought into London south of the marker. This practice continued until 1890. The obelisk was moved to the opposite side of the river in 1984.

58. The Five Arches

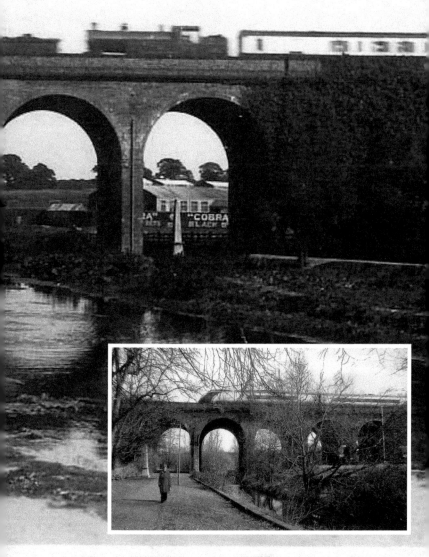

...ver the Colne, Watford.

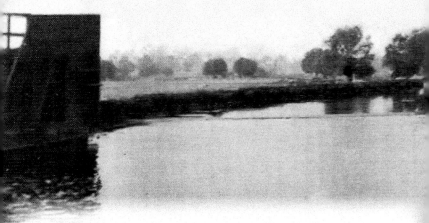

47. RIVER COLNE BATHING LIDO

It was here in the shadow of the Five Arches railway viaduct over the River Colne that an open-air public bathing place was cordoned off to form a large square-shaped lido. Around this area were a number of wooden changing cubicles and a spectators' viewing gallery. However, conditions were most unhygienic when compared to modern standards, and following the discovery of sewage in 1936, a decision was made by Watford Council for the bathing place to be closed, no doubt an unpopular ruling for many, despite the new state-of-the-art indoor swimming pool that had opened in Hempstead Road three years earlier.

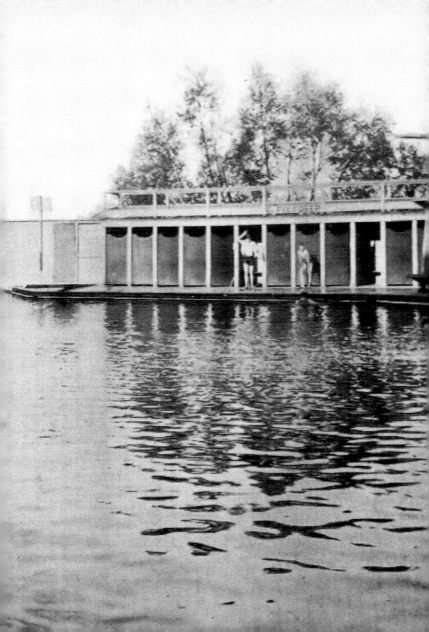

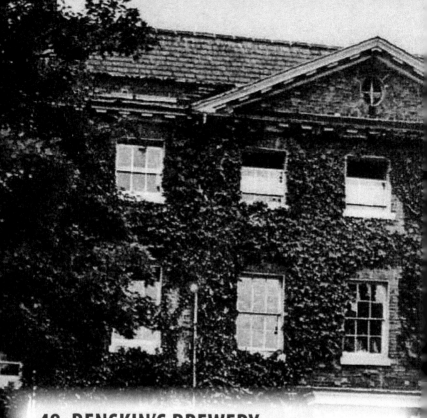

48. BENSKIN'S BREWERY

This distinctive Grade II listed building, built by Edward Dawson in 1785, was once owned by John Dyson, a brewer who had originally founded the Cannon Brewery in the High Street. In 1867, the business passed to the Benskin family who lived in the house, the brewery being at the rear. With a successful takeover bid from Ind Coope in 1957 and further mergers during the intervening years, brewing continued in Watford until production ceased in the early 1970s. The site was subsequently demolished and redeveloped in 1979, with the fine Georgian mansion now home to Watford Museum.

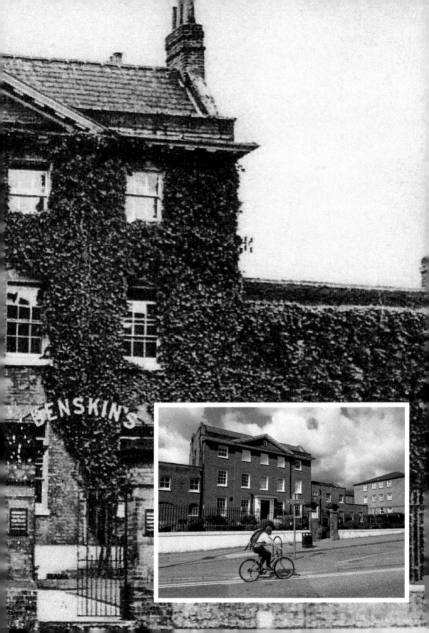

49. WATFORD ENDOWED SCHOOL

The buildings for both the boys and girls at the new Watford Endowed School in Derby Road were opened by the Earl of Clarendon in 1884, with an initial intake of sixty-nine boys and forty-six girls. However, by the turn of the nineteenth century it was apparent that both schools were far too small to cope with the increasing demand for places, and steps were taken to find alternative sites. By 1907, new premises had been built in the Crescent (now Lady's Close) for the girls, with the boys moving into a modern and spacious development in Shepherd's Road five years later, Watford's new grammar schools. The old Endowed School buildings in Derby Road are now the Central Primary School and Nursery.

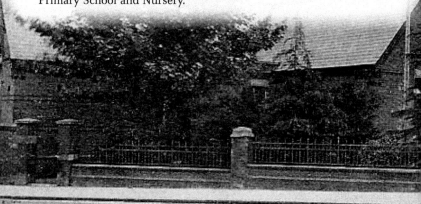

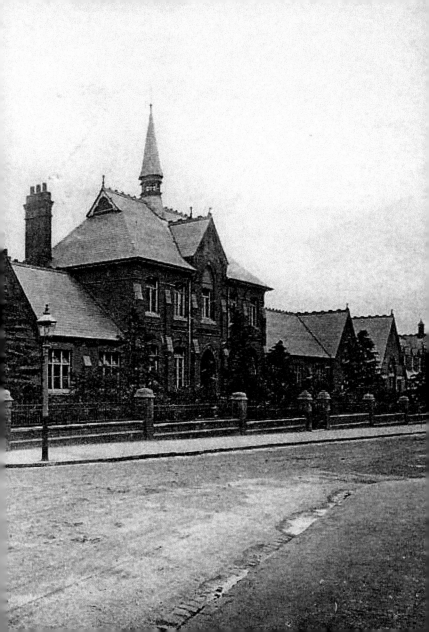

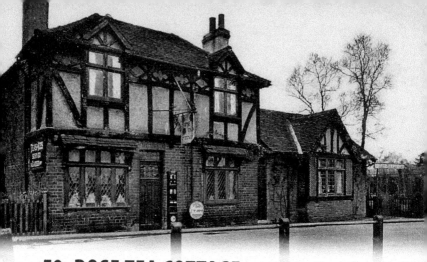

50. ROSE TEA COTTAGE

Now called Rose House, this charming locally listed building in Watford Heath was formerly Rose Tea Cottage, a quintessentially English tearoom with a lovely well-stocked garden to the rear containing ornate trelliswork and a pretty gazebo. The property was constructed in the mid-nineteenth century and may have been part of the Oxhey Grange Estates' development of Watford Heath. Sadly, the tearoom is no more, with the property now under private ownership.

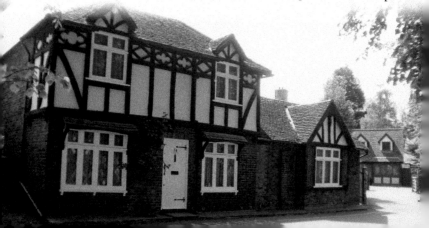